Harry Potter™

DOBBY
THE FREE ELF

A Running Press® Miniature Edition™

Running Press
Hachette Book Group
1290 Avenue of the Americas, New York, NY 10104
www.runningpress.com
@Running_Press

First Edition: April 2018

Published by Running Press, an imprint of Perseus Books, LLC,
a subsidiary of Hachette Book Group, Inc.

The Hachette Speakers Bureau provides a wide range of authors for speaking events.
To find out more, go to www.hachettespeakersbureau.com or call (866) 376-6591.

The publisher is not responsible for websites (or their content) that are not owned by the
publisher.

ISBN: 978-0-7624-6310-7 (paperback)

INTRODUCTION

Dobby, Harry Potter's most loyal friend, is surely the wizarding world's bravest house-elf. Dobby was bound to serve his family, the Malfoys, for life.

Yet Dobby had a reverence for The Boy Who Lived and a desire to keep him safe at all costs.

Though his attempts to help Harry often caused more harm than he intended, evoking the ire of Harry's uncle and once losing Harry all the bones in his arm, his sincere desire to do the right thing

s what we remember of Dobby the house-elf.

Dobby's fateful last act was saving Harry's life, and in his final moments, he spoke of friendship. From Dobby we learn everything there is to know about honor, loyalty, sacrifice, and most of all, love.

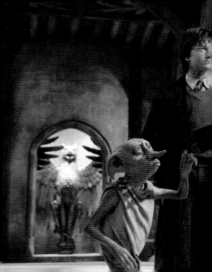

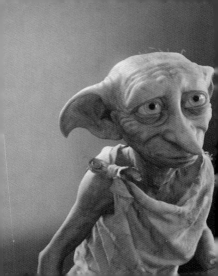

"Harry Potter—such an honor it is!"

—Dobby
from *Harry Potter and the Chamber of Secrets*

"Dobby has to protect Harry Potter— to warn him."

—Dobby
from *Harry Potter and the Chamber of Secrets*

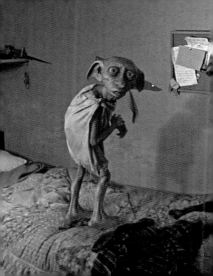

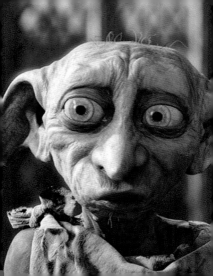

*Dobby has heard of
your greatness, sir,
but never has he been
asked to sit down by
a wizard!"*

— Dobby
from *Harry Potter and the
Chamber of Secrets*

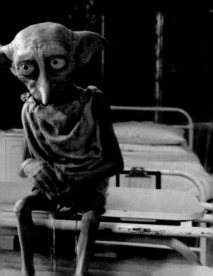

"Dobby remembers how it was before Harry Potter triumphed over He-Who-Must-Not-Be-Named."

—Dobby

from *Harry Potter and the Chamber of Secrets*

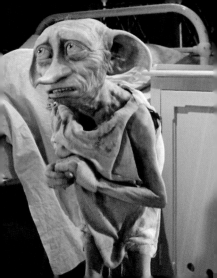

"Harry Potter must not go back to Hogwarts School of Witchcraft and Wizardry this year. . . . There is a plot. A plot to make most terrible things happen!"

—Dobby
from *Harry Potter and the Chamber of Secrets*

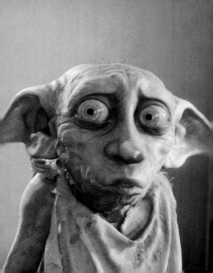

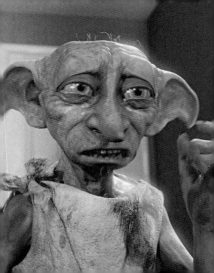

"Dobby only wants
Harry Potter to
be safe."

— Dobby
from *Harry Potter and the
Chamber of Secrets*

*"Master has given
Dobby a sock!"*

—Dobby
from *Harry Potter and the
Chamber of Secrets*

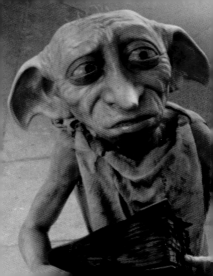

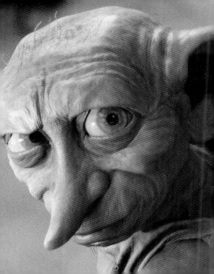

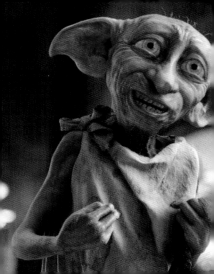

Master has presented Dobby with clothes! Dobby is free."

—Dobby
from *Harry Potter and the Chamber of Secrets*

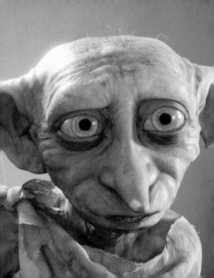

You shall not harm Harry Potter!"

—Dobby
from *Harry Potter and the Chamber of Secrets*

"Dobby never meant to kill! Dobby only meant to maim, or seriously injure!"

—Dobb

from *Harry Potter and th Deathly Hallows—Part*

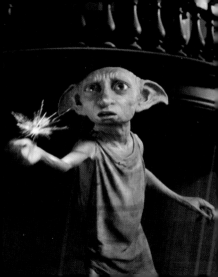

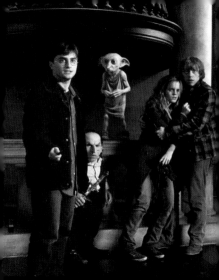

"Dobby has no master. Dobby is a free elf, and Dobby has come to save Harry Potter and his friends!"

— Dobby
from *Harry Potter and the Deathly Hallows–Part 1*

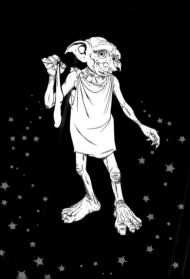

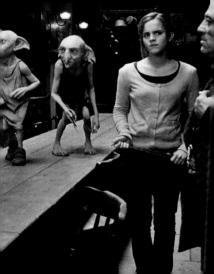

"*Such a beautiful place to be with friends.*"

—Dobby
from *Harry Potter and the Deathly Hallows–Part 1*

*"Dobby is happy
to be with his friend
Harry Potter."*

— Dobby
from *Harry Potter and the
Deathly Hallows–Part 1*

"Dobby will always be there for Harry Potter."

—Dobby
from *Harry Potter and the Deathly Hallows–Part 1*

"'Sir'? I like her very much."

—Dobby
from *Harry Potter and the Deathly Hallows–Part 1*

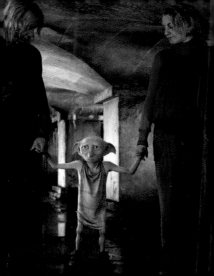

This book has been bound using handcraft methods and Smyth-sewn to ensure durability.

Text compiled by Danielle Selber.

Designed by T.L. Bonaddio.